FRAMED BUTTERFLIES

BY HILLROCKS COLORING BOOK

Copyright © 2018 BY HILLROCKS COLORING BOOK

All rights reserved. No part of this publication may be reproduced, distributed, or transmitted in any form or by any means, including photocopying, recording, or other electronic or mechanical methods, without the prior written permission of the author, except in the case of brief quotations embodied in critical reviews.

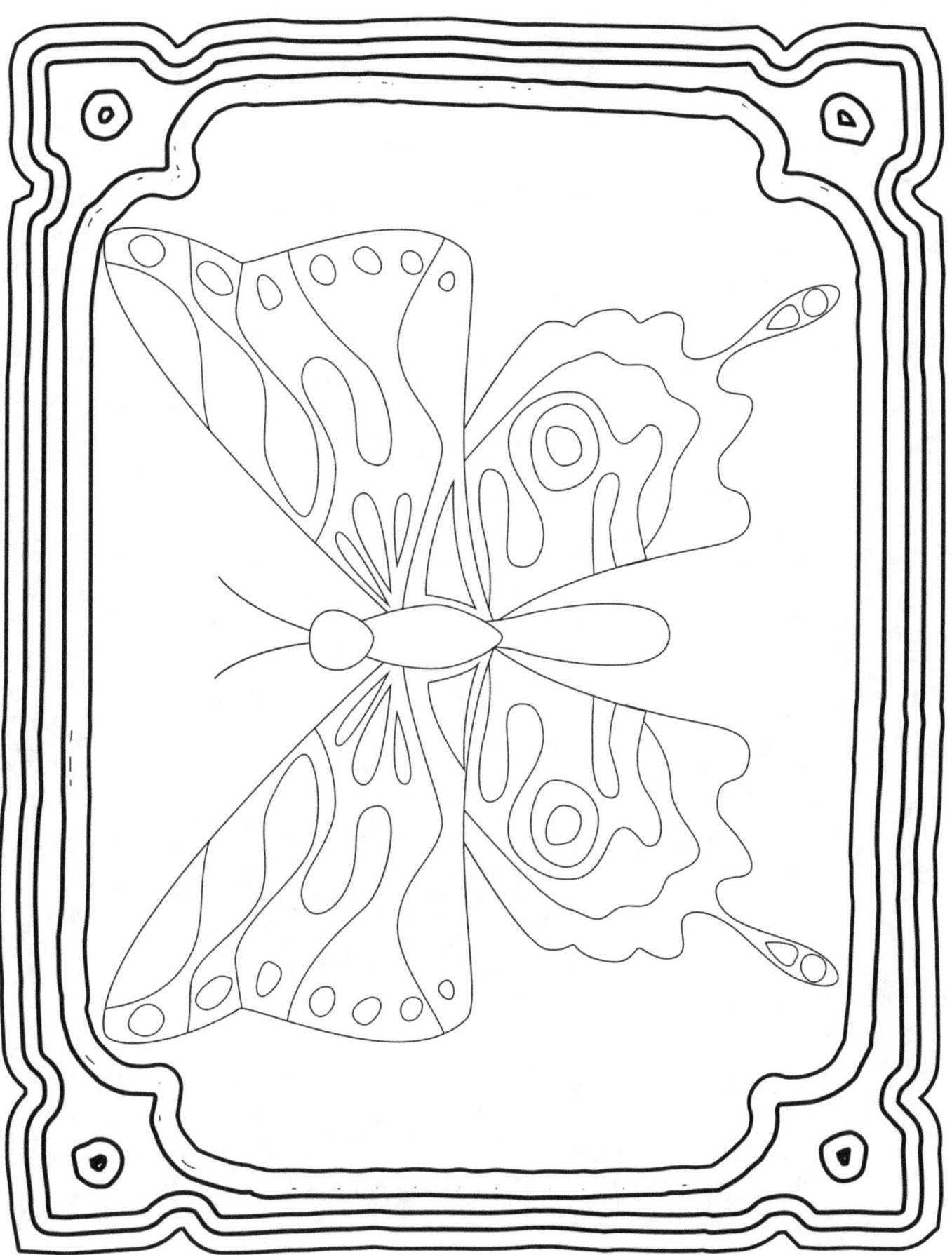

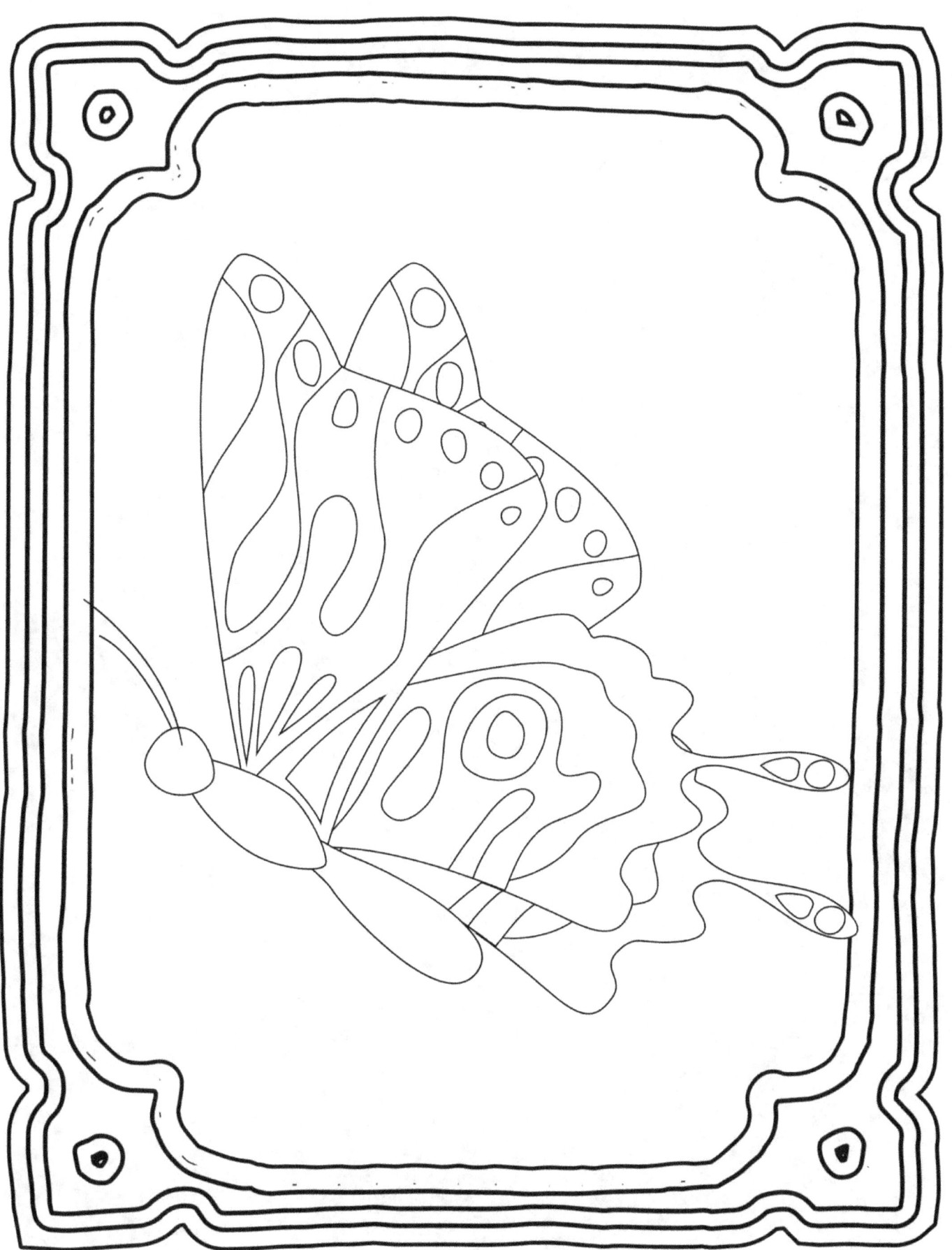

www.ingramcontent.com/pod-product-compliance
Lightning Source LLC
Chambersburg PA
CBHW081652220526

45468CB00009B/2625